IMAGES
*of America*

# LOS ANGELES'S CENTRAL AVENUE JAZZ

On the Cover: As the famed Club Alabam looms in the background, bandleader Lionel Hampton (left) greets a crowd of well-wishers at a parade in his honor on Central Avenue. The sign on the car notes his appearance the following day at the Lincoln Theater, which was 20 blocks to the north. Although he was not from Los Angeles and he did not live there long, his career got its biggest boost from the area, and he returned frequently. (Courtesy of the Shades of LA Collection, Los Angeles Public Library.)

# IMAGES of America
# LOS ANGELES'S CENTRAL AVENUE JAZZ

Sean J. O'Connell

ARCADIA
PUBLISHING

Copyright © 2014 by Sean J. O'Connell
ISBN 978-1-4671-3130-8

Published by Arcadia Publishing
Charleston, South Carolina

Printed in the United States of America

Library of Congress Control Number: 2013947322

For all general information, please contact Arcadia Publishing:
Telephone 843-853-2070
Fax 843-853-0044
E-mail sales@arcadiapublishing.com
For customer service and orders:
Toll-Free 1-888-313-2665

Visit us on the Internet at www.arcadiapublishing.com

*To my wife Christina, who never imagined she would spend so much of her time listening to old-timey jazz.*

# CONTENTS

| | | |
|---|---|---|
| Acknowledgments | | 6 |
| Introduction | | 7 |
| 1. | California, Here I Come | 9 |
| 2. | The Dunbar Hotel | 23 |
| 3. | Hey! Ba-Ba-Re-Bop | 33 |
| 4. | Central Avenue Blues | 95 |
| 5. | Things Ain't What They Used to Be | 115 |

# ACKNOWLEDGMENTS

This book would not have been possible without the assistance of the jazz community in Los Angeles. Brick Wahl, James Janisse, Ken Poston, Joon Lee, Steven Isoardi, Ted Gioia, Armand Lewis, and Chris Barton have been instrumental in supporting the completion of this project. Nate Carter at the Dunbar Hotel opened up the newly renovated facility to me and pointed me in the direction of the spectacular roof view. Southern California libraries, including the Los Angeles Public Library, the USC Library, UCLA, and California State Northridge, are invaluable for their access to great snapshots from history. Check out their collections. My wife, Christina, has shown patience and support I could only dream of while we drove up and down Central Avenue looking for swinging ghosts (while my newborn daughter has served as a terrific editor between feedings, changings, and fits of tears). Most importantly, my parents, Fern and Dave, have always nurtured my interests in music and were always willing to take their teenage son to South Central to soak up a little culture.

Unless otherwise noted, all images are from the author's collection.

# INTRODUCTION

Selling the Southern California lifestyle has never been particularly difficult. Sunshine and palm trees have lured millions to Los Angeles since the moment the city was incorporated in 1850. Its ceaseless sprawl has steadily spilled into the surrounding desert with the dubious promise of health and prosperity. For all those lucky enough to actually soak up the Pacific Ocean sunsets, there were twice as many denied that natural beauty in order to keep the illusion paved, electrified, and smelling of orange blossoms. Many of those optimistic transplants flocked to Los Angeles to escape the inhospitable climates of places like the American South only to find things were as rigidly segregated as anywhere else.

Los Angeles is composed of over 150 neighborhoods, many of them identifying themselves with one particular ethnic group. Some of these divisions were happily self-imposed while others were written into law. Central Avenue, which strikes like a dagger from downtown Los Angeles through Watts to northernmost Long Beach, was the strip allotted to African Americans, focusing primarily on a five-mile line between First Street in downtown and Slauson Avenue to the south. Due largely to restrictive covenant laws that allowed home owners to refuse sales to anyone whose color they did not approve, African Americans (both native and foreign) were confined to this narrow residential parcel, leaving few options in the nearly 500 square miles of Los Angeles county.

As a result, South Los Angeles was united solely by skin color with a diversity of educations, incomes, and aspirations changing from one home to the next. Doctors and lawyers lived next to dockworkers and janitors, and high-society opera singers borrowed sugar from barefoot bumpkins. The resulting cultural diversity led to a working-class, landlocked island alternative filled with hotels and nightclubs that hosted and nurtured some of the most significant jazz musicians of the 20th century.

The cliché of beach bunnies and boardwalks was applied to all of Los Angeles's exports. West Coast jazz was no exception, becoming synonymous with the scene at Hermosa Beach's famed Lighthouse and the sun-dappled swingers with saxophone cases full of sand and a year-round wardrobe of short-sleeve shirts and khakis. It was a predominantly Caucasian facade, and it took a lot away from the hard-edged innovators toiling away 24 hours a day in the backrooms of Central Avenue chicken joints. It may not have been as charming on the Avenue, but an honest and impassioned sound arose from the cramped venues that could rival New Orleans or New York in terms of forward-thinking musicianship.

As jazz rose from ragtime in the early 20th century, it learned to walk in the 1910s on the blood-splattered streets of New Orleans's Storyville. Musicians like Jelly Roll Morton, Kid Ory, and Louis Armstrong created a new musical language that was uniquely American and full of swing and inspired improvisation. When Storyville was closed with the battered end of a police baton in 1917, the musicians who were making a living there spread in every direction. Midwestern cities like Chicago and Kansas City inherited a few horn players while New York attracted a few more. Those uninterested in shoveling snow headed due west.

The most concentrated commercial strip of Central Avenue revolved around the Dunbar Hotel, which is on the corner of Forty-second Place. Built in 1928, it was originally known as the Hotel Somerville; however, the collapsing state of American economics caused ownership of the towering edifice to change hands by 1930, and it was renamed the Dunbar Hotel. Lodgings were not easy to come by for African Americans, but the Dunbar Hotel was African American friendly and catered to a high-class clientele. When Hollywood came knocking for jazz musicians, artists like Duke Ellington, Louis Armstrong, and Cab Calloway would haul their trunks down from the equally grandiose Union Station to set up at the Dunbar Hotel. On off nights, they would visit the dozens of clubs within walking distance of the lobby.

In the 1920s, Los Angeles's African American population was less than 40,000. Cities like Watts and Compton were still farmland, and folks of every ethnicity could find a small parcel to call their own. By the 1940s, that population had doubled but the space remained the same. In 1945, alto saxophonist Charlie Parker arrived in Los Angeles for a nightclub stint, unaware that he would be spending the next year and a half of his short life in and around Central Avenue. He was welcomed with open arms by young modern jazz practitioners like pianist Hampton Hawes and trumpeter Howard McGhee, who brought him around to jam sessions and soaked up as much knowledge as Parker's deteriorating body could dispense.

Less than 10 years later, the Central Avenue scene had all but disappeared. After World War II ended, the booming defense industry in Southern California no longer needed to keep their plants running 24 hours a day. As a result, many African American employees were the first to be let go. Their cash-rich pockets quickly emptied, leaving entertainers low on the priority spending scale. In 1948, after years of fighting, restrictive covenants were repealed in Los Angeles, opening up a wide array of suburban options for those who could afford to escape the overcrowded confines of Central Avenue. Many of the wealthiest residents headed west for the vistas of Baldwin Hills, and numerous entertainment options followed them to streets like Western Avenue and Crenshaw Boulevard. Another civil rights victory, the amalgamation of the segregated musicians union, was finalized in 1953. The merger resulted in the closing of the Central Avenue musicians union, and that focus and fraternity shifted to the Hollywood offices. The rise of R&B and rock and roll further commandeered the record charts, and many jazz musicians were forced to adapt or lower their already dubious living standards.

By the 1960s, it was all gone. The Dunbar remained standing but quickly fell into decline. Jazz fans were scattered across the county and seemed to agree to congregate in Hollywood, a location considerably more glamorous than South Los Angeles. Riots and poverty dismantled the remaining evidence of a once-thriving neighborhood. In the mid-1990s, the Central Avenue Jazz Festival was started to preserve what memories remained. It has continued to draw thousands annually to hear jazz greats (and future greats) carry on a treasured tradition in the shadow of the Dunbar Hotel. A nightlife resurgence is unlikely to reoccur on Central Avenue, but a concentration of nightlife is unlikely to organically pop up anywhere again because of all of the affordable entertainment options available to the 21st-century man. That is why it is essential to remember that for nearly half a century, a small, neglected strip of South Los Angeles was home to some of the greatest innovators of American music.

# One

# CALIFORNIA, HERE I COME

*When the wintry winds start blowing
And the snow is starting in the fall
Then my eyes went westward knowing
That's the place I love best of all.*

—Al Jolson, Bud de Sylva, and Joseph Meyer, composers
"California, Here I Come"

Whether it was due to employment, the lure of the Pacific lifestyle, or just the end of the train tracks, people of all classes and colors flocked to Los Angeles seeking fortune and fame. Some managed to do both at once while others found neither. The double-fisted punch of Prohibition and the Great Depression made it awfully hard for entertainers, established or otherwise, to get a piece of the pie. New Orleans jazz innovators Kid Ory, Jelly Roll Morton, and Louis Armstrong had three vastly different experiences trying to piece together a living in Los Angeles. One retired prematurely, one expired prematurely, and the third was arrested between film shoots. There was work to be had in Hollywood, and marquee entertainers like Armstrong and Duke Ellington were getting the occasional payday. When they did, they brought their bands with them and sought out like-minded individuals during their extended stays, helping to enrich a community that was already swarming with talent.

Al Jolson's Golden State rallying cry "California, Here I Come" resonates as clearly today as it did when it was released in 1924. Three years before Jolson's *The Jazz Singer* introduced sound to film, this song echoed across the country by way of Broadway and record stores. It became an instant American standard and enticed many to make the move west. In the 1930s, bandleader Fletcher Henderson found success with a series of variations on the theme entitled "Casa Loma Stomp," and Ray Charles opened his chart-topping LP *The Genius Hits The Road* with a swinging rendition of the tune. Even pop singers took a stab at it, with Freddy "Boom Boom" Cannon and ABBA making goofy versions 40 years after it first appeared on the radio; however, none captured the majesty and potential like Jolson. (Courtesy of the Quincy Inara Music Collection.)

By the early 1920s, Los Angeles operated the largest electric railway system in the world. The tracks of the Pacific Electric and the Los Angeles Railway connected far-flung corners of Los Angeles County until 1964, when car ownership and deteriorating tracks forced its closure. There are countless conspiracies about the system's demise; regardless, the demolition succeeded in isolating large communities. With the expanding freeway system in Los Angeles, Central Avenue was no longer a major north-south thoroughfare. Drivers could easily take the 110 Freeway or the 710 Freeway and travel from downtown Los Angeles to Long Beach in half the time. The J, S, and U Lines served Central Avenue, with cables running above the narrow street, before being slowly phased out by bus lines.

Jelly Roll Morton was the self-proclaimed inventor of jazz. Born in 1890, Morton made a name for himself in New Orleans as a bandleader, arranger, and songwriter before moving to Los Angeles to find work in 1917. Morton and his wife stayed for several years and ran a hotel at 1013 1/2 South Central Avenue, which Morton used as his pimping office. The building still stands today and continues to be used as a hotel. This photograph was taken a few blocks up the avenue in front of the Cadillac Café. From left to right are "Common Sense" Ross, Albertine Pickens, Morton, Ada "Bricktop" Smith, Eddie Rucker, and Mable Watts. The charismatic bandleader wrote and recorded a considerable collection of his own compositions, including sensations such as "The Crave" and "King Porter Stomp." His arrogance about his place in the history of jazz rubbed a few people the wrong way, but, by the mid-1920s, he had secured a contract with Victor Records where he recorded with his most famous ensemble, the Red Hot Peppers. The small ensemble recordings show the roots of the New Orleans sound with a loose sense of swing and collective improvisation-based sound. (Below, courtesy of the Quincy Inara Music Collection.)

One of Morton's most famous compositions, "Wolverine Blues," features a cowriting credit with Central Avenue business owners Benjamin and John Spikes. The song features Morton's unique piano style, which employed a ragtime bounce in his left hand with a series of fluttering octaves in his right hand. His piano playing was an intricate, split-brained display of melody and movement that few of his time could rival. (Courtesy of the Quincy Inara Music Collection.)

Morton returned to Los Angeles in the early 1940s to launch a comeback. He had booked rehearsal time at the Elks Hall on Central Avenue when he grew ill. Due to negligent medical care following an earlier stabbing, Morton's health had rapidly deteriorated, leaving him with persistent breathing issues. It took more than a decade for his widow to get around to placing a headstone at his grave. She only spent her own money after a local traditional jazz society organized a fundraiser to pay for the headstone. The money was instead spent on the stone of banjoist Johnny St. Cyr.

Trumpeter Buddy Bolden famously discovered trombonist Kid Ory in New Orleans. When work dried up in New Orleans, Ory settled in Los Angeles around 1919. He tried his hand at the California lifestyle, assembling a band to play around the avenue for six years before giving Chicago a try, much like Morton had done. California was not able to provide enough work.

Ory has the honor of being the first musician to record New Orleans–style jazz on the West Coast. He paired up with the Sunshine Record Company on Central Avenue to release his recordings. They were warmly received by West Coast record buyers, selling out quickly in the new medium of recorded sound.

14

"Muskrat Ramble" is one of the most recorded New Orleans jazz tunes ever written. There is some dispute over authorship (Lil Hardin and Louis Armstrong also made claims), but it was believed to be written in 1921 while Ory was based in Los Angeles. However, the original recording was made under Armstrong's name and featured all of the disputed authors. Lyrics were added in the 1950s, and the tune continues to stay in the standard repertoire. (Courtesy of the Quincy Inara Music Collection.)

Ory returned to Los Angeles in the late 1920s and gave up playing for over a decade. Before being rediscovered in the 1940s, he took a job sorting mail and raised chickens to make ends meet. He enjoyed a richly deserved revival before retiring for a second time in Hawaii (this time without having to feed chickens). Although he died in Honolulu at the age of 86, his body was buried at Holy Cross Cemetery in Culver City, California, a few feet from Bing Crosby and Bela Lugosi.

Benjamin Spikes, along with his brother John, opened a music store at 1203 South Central Avenue in 1919. As boastful as his friend Jelly Roll Morton, Spikes billed himself as the "World's Greatest Saxophonist" when he and his brother performed as the Original So-Different Orchestra in the mid-1910s. The Spikes Brothers music store became the centerpiece of the Los Angeles jazz scene for a while, selling instruments and operating a record label and publishing company. They even ventured into filmmaking in the mid-1920s. It helped that the African American musicians union Local 767 was located five blocks away. The two brothers made quite a mark on the scene by recording many of their New Orleans friends and supplying countless Central Avenue musicians with the drumsticks and reeds that would help lead them to notoriety.

Louis Armstrong spent most of 1930 living in Los Angeles. He worked primarily in Culver City at the Cotton Club, with Lionel Hampton as his drummer, entertaining movie stars whose studios were close by. Radio broadcasts and the occasional film cameo kept Armstrong busy during his time. He was in Los Angeles long enough to buy a home, but a bust for possession of marijuana threw him a curveball. Thankfully, the incident did not derail his career, but he left shortly after for more hospitable climates. (Above, photograph by William Gottlieb; below, courtesy of the Quincy Inara Music Collection.)

From 1936 to 1961, Samuel Browne taught music at Jefferson High School (two blocks east of Central Avenue). His influence was noted by many of his students, who included future jazz legends Dexter Gordon, Eric Dolphy, Chico Hamilton, Vi Redd, and Horace Tapscott. He impressed upon them the musical fundamentals, which were augmented by their after-hours education on the avenue.

Gilmore Millen's *Sweet Man*, published in 1930, is one of the earliest fictional accounts of life on Central Avenue. Most of the book revolves around the American South, but Central Avenue nightlife, affectionately referred to as the "Beale Street of the West," is featured toward the end. Amusingly, the Los Angeles Public Library still has the tattered original printing in circulation.

18

Once Hollywood added sound to their films, they needed musicians to fill those speakers. Duke Ellington and his orchestra regularly visited Los Angeles to record and appear in shorts and feature lengths like *Black and Tan* and Amos 'N' Andy's *Check and Double Check*. The debonair Duke arrived on a private train car and frequently stayed on the avenue. He displayed a lifestyle young musicians could aspire to while churning out a string of hits that they could only dream of. (Courtesy of the Quincy Inara Music Collection.)

The 2,100-seat Lincoln Theater, located at 2300 South Central Avenue, was considered the "West Coast Apollo" when it opened in 1927. At a cost of half a million dollars, the opulent palace was the centerpiece of a grand night out on Central Avenue. The big bands of Lionel Hampton and Duke Ellington regularly held court on the stage while local revues and comedians filled the theater during the week. Smaller clubs popped up to take in spendy revelers dressed up and looking for action, including the Jungle Room (2407 South Central Avenue), the Kentucky Club (2220 South Central Avenue), and the Cabin Inn (2305 South Central Avenue). The Moorish Revival theater became a church in the early 1960s and was listed in the National Register of Historic Places in 2009.

The Golden State Mutual Life Insurance Company was a prime example of an African American–owned business on Central Avenue—there were not many. People who did not live in the area and merely profited from the lease agreements owned most of the businesses. The company was immensely profitable and built its headquarters at 4261 South Central Avenue in 1928. Though the company still exists, they are no longer tenants.

The *California Eagle* ran continuously for 85 years. Starting in the late 1800s, the African American newspaper reported on news pertinent to the neighborhood. While documenting the nightlife and gossip of the thriving neighborhood, it also led the charge in civil rights reform. Charlotta Bass (center) ran the newspaper from the offices at 4071–4075 South Central Avenue for nearly 40 years. In the early 1950s, Bass sold the *California Eagle* to attorney Loren Miller, who was able to keep it afloat until 1964. (Courtesy of the Charlotta Bass Collection, USC Library.)

Bandleader Curtis Mosby was one of the first musicians to perform at the Lincoln Theater. Along with his Blues Blowers, he was a regular presence on the avenue and was even declared the "Mayor of Central Avenue"; however, he left his real impact as a business owner. He opened the Apex on the Dunbar Hotel block of Central Avenue in 1928. After it closed, he opened a few venues elsewhere in California before returning to open Club Alabam, which was located in the same spot as the Apex. Featuring dancers, bands, and decadent hospitality, Club Alabam quickly became the hottest and ritziest nightclub on Central Avenue. Unfortunately, Mosby was dogged by questionable investments, which eventually led to him serving a couple of years in jail for tax evasion.

# Two

# The Dunbar Hotel

*When the steeple bell says, 'Goodnight, sleep well'*
*We'll thank the small hotel*
*We'll creep into our little shell*
*And we will thank the small hotel together.*

—Richard Rodgers and Lorenz Hart, composers
"There's a Small Hotel"

From the roof of the Dunbar Hotel, there is still an unobstructed 360-degree view of Los Angeles's suburban sprawl. The five-story structure was built as the Hotel Somerville in 1928, the same year the City of Los Angeles completed its 32-story city hall (located 3.5 miles directly north in downtown). Located on the corner of Forty-second Place and South Central Avenue, the Dunbar Hotel changed owners and names in 1930. It quickly became the centerpiece of the Central Avenue scene, offering accommodations to out-of-towners while providing a beauty parlor, liquor store, messaging services, and a few communal spaces equipped with a bar and a bandstand. Well into the 1950s, a large number of Los Angeles hotels were segregated. Finding luxurious accommodations for African Americans was fairly limited; however, the Dunbar served as a jazz embassy for the road weary, welcoming swinging dignitaries with the warm reception they richly deserved.

The high-ceilinged lobby of the Hotel Somerville, located at 4225 South Central Avenue, seemed to have a piano tucked into every corner. Entertainment and leisure were the goals of the Somerville, and they were abundant. An advertising board on the mezzanine highlights an appearance by Alton Redd and his Tivoli Theater band, named after a venue located further down at 4319 Central Avenue. Delicate Spanish-style frescoes were painted above the lobby and light streamed in from the courtyard off East Forty-second Place, which provided ample space to sit and read while planning a night's adventure. (Both, courtesy of the Quincy Inara Music Collection.)

Despite the hotel's name change in 1930, the ghosts of the Somerville are still stamped into the entrance of the Dunbar Hotel today. The cracked slab sits on the sidewalk of Central Avenue in the middle of the structure. Imagine the many cigarette butts and shoe styles this sturdy floor mat has experienced from the hundreds of thousands of pairs to grace its entryway.

5 ROOMS—75 ROOMS WITH BATH. RATES $1.00 PER DAY AND UP. WEEKLY RATES $5.00 AND

The Dunbar Hotel (not yet surrounded by giant trees in this photograph) boasted 115 rooms across five floors. While daily rates offered a break for those just passing through, weekly rates catered to artists and musicians looking to spend an extended stay on the avenue. (Courtesy of the Quincy Inara Music Collection.)

Paul Laurence Dunbar only lived to the age of 33 before succumbing to tuberculosis. He likely never visited California and would not have seen the Dunbar Hotel if he had; he died 24 years before it was dedicated to him. He was a poet, novelist, and playwright with close ties to the Wright brothers in his native Ohio. The title of Maya Angelou's autobiography, *I Know Why the Caged Bird Sings*, immortalized one of Dunbar's most enduring stanzas: "I know why the caged bird sings, ah me, / When his wing is bruised and his bosom sore– / When he beats his bars and he would be free; / It is not a carol of joy or glee, / But a prayer that he sends from his heart's deep core, / But a plea that upward to Heaven he flings– / I know why the caged bird sings!"

Architect Steven Fader had the daunting task of restoring the Dunbar Hotel. It had fallen into disrepair before a group took over the facility and helped to turn it into a senior and low-income housing community. Comparisons to photographs from 85 years prior show just how exact the result is: the frescoes and light fixtures are restored, a piano cries for attention in the corner, and the same light streams in from above.

28

The lush outdoor courtyard has immaculate tile work with a bubbling fountain wrapped in Spanish tile. The skylights above keep the area bright while the plant life keeps things cool. A small balcony on the second floor opens onto the small public space. The next project is to fill the vacant corner of the building with a restaurant, thereby finally restoring the entire complex to its former glory.

Aside from the four-story tree towering above Central Avenue, not much has changed on the outside of the Dunbar Hotel. The car models have changed and the streetcar no longer rattles the windows; otherwise, the building is immaculately preserved.

Segregated businesses in Los Angeles made it extremely difficult for many to find a place where they could be comfortable. No matter how much money or respectability a person might have had, they were frequently turned away from the Hollywood hotels. Thus, the guest list at the Dunbar Hotel was an astounding collection of who's who in the entertainment world. (Photograph by William Gottlieb.)

Vocalist Billie Holiday (above) was a regular guest and bandleader Cab Calloway (right) often hung his zoot suits in one of the 115 closets available. In order to catch a glimpse (and maybe a little career advice), young musicians would wait out front when they knew someone famous was in town. (Photograph by William Gottlieb.)

The Dunbar Hotel was placed in the National Register of Historic Places in January 1976. The building had become apartments after having been vacant for 13 years, suffering from neglect and vandalism. Owner Bernard Johnson briefly opened a museum of black culture in 1990, but the building was foreclosed on 18 years later. The project has seen a more promising rebuild in 2013, with a long-term plan for its rightful place in Los Angeles's African American history.

The same Dunbar sign has hung on the north corner of the building since the 1930s. It is visible on the postcard on page 26. The sign got a boost of new neon when the building was renovated, and it now glows nightly above Central Avenue.

The *Green Book* was an essential guide for African American travelers in unknown and inhospitable areas of the United States. Independently compiled, the guide offered the locations of hairdressers, restaurants, nightclubs, and lodgings that were friendly to out-of-town African Americans. The listing for Los Angeles shows how many of these businesses were clustered around Central Avenue. The guide was indispensable in helping travelers to avoid confrontation and to maintain their dignity in the face of bigotry.

# Three

# HEY! BA-BA-RE-BOP

*Momma's on the chair
Poppa's on the cot
Baby's on the floor blowin' his natural top sayin'
Hey! Ba-ba-re-bop!*

—Lionel Hampton and Curley Hamner, composers
"Hey! Ba-Ba-Re-Bop!"

As physically destructive as World War II was, it brought prosperity to the United States. The demand for laborers was so high that color lines were briefly forgotten in order to get America's war machine up to full speed. Defense industry employers in Long Beach and San Pedro were fortifying the shores for a West Coast invasion, and the result was a steady paycheck for anyone willing to put in the hours. The residents of Central Avenue helped punch those clocks, and tens of thousands of nonresidents from elsewhere in America were lured by the promise of work. With all those paychecks floating around, people needed a place to spend them, and the clubs of Central Avenue were more than happy to provide as many bottles and saxophones as it took. With shifts ending 24 hours a day, nightclubs stayed open until all hours. Musicians were getting paid, seats were getting filled, and the music was evolving rapidly as a result. Bebop overcame the big bands before R&B overtook them both. It was a beautiful period of unhinged artistry and newfound wealth; however, it did not last long.

Raymond Chandler's 1940 hard-boiled noir classic opens on Central Avenue. The first sentence of the book reads, "It was one of the mixed blocks over on Central Avenue, the blocks that are not yet all negro." In Chandler's second novel to feature the grizzled gumshoe, Det. Philip Marlowe dodges and administers punches in pursuit of a lost dame. Numerous film adaptations were made, but none captured the easy grit of Central Avenue that Chandler was aiming to depict.

The boogie-woogie groove of "Central Avenue Breakdown" features both Lionel Hampton and Nat King Cole, two regulars on the Central Avenue scene, on piano. The tune was recorded in May 1940 for the Victor label. The swinging piano work is a little atypical of both artists, sounding twice as fast as their usual economic style. The persistent ostinatos of one pianist bounce like a rent party as the other holds down the repeating bass figure. It is a charming instrumental that captures the excitement of the Central Avenue scene right as it was reaching its peak.

Lionel Hampton was not from Los Angeles, but he was a hometown hero nonetheless. The drummer/vibraphonist/pianist strolled through jazz history. He moved to California in the late 1920s to join Curtis Mosby's group. He was a consummate showman with enough drumstick tricks to fill a drum line. He was a member, with Benny Goodman, of one of the first racially integrated bands, and his reputation continued to grow from there. Hampton frequently returned to Los Angeles to play at the Lincoln Theater and the Cavalcade of Jazz, driving crowds into a frenzy with his playful crowd-pleasing antics. Tunes like "Hey! Ba-Ba-Re-Bop" and "The Land of Oo-Bla-Dee" captured a bop-inflected nonsense that became synonymous with jazz cats and their dames. (Left, courtesy of the Shades of LA, Los Angeles Public Library; below, courtesy of the Quincy Inara Music Collection.)

Nat King Cole was the suave sophisticate with a nice suit and a cigarette. Before he was in every housewife's record collection singing about Mona Lisa, he was building his career on Central Avenue with his trio and working his way up to conquer Hollywood with his smile and croon. He was a jazzman with a swinging touch on the piano that greatly influenced musicians like Ray Charles and Oscar Peterson. Along with guitarist Oscar Moore and bass player Wesley Prince, Cole created a whole new format for the piano trio, trading the drums for another melodic instrument that managed to groove just as fast and smooth as if there were someone solely keeping the beat. (Photograph by William Gottlieb.)

The story of eden ahbez could fill a book. The enigmatic self-made guru reportedly handed Cole's manager a copy of his tune "Nature Boy" backstage at the Lincoln Theater in hopes that Cole would sing it. Cole did and spawned a massive hit in 1948. The song was as cryptic as the songwriter, but it has endured as an American standard. Cole's success while recording tunes like "Route 66" and "Unforgettable" for Capitol Records was as important for the label as it was for him. He helped to turn the company into a powerhouse whose emblematic tower still blinks above the intersection of Hollywood Boulevard and Vine Street. (Below, courtesy of the Quincy Inara Music Collection.)

Art Tatum was known by anyone who heard him as a god of the piano. The nearly blind prodigy helped to redefine the possibilities of the solo piano. His breakneck passages and endless supply of melodic ideas led to him being worshipped as an unparalleled master to this day. A longtime Los Angeles resident, he was known to settle in at any piano along Central Avenue with a case of Pabst Blue Ribbon and rattle off an endless torrent of swing. He died at the age of 47 in Los Angeles from uremia. Though short-lived, Los Angeles–based Comet Records recorded many jazz talents, including Red Norvo, Dizzy Gillespie, Charlie Parker, and Tatum, before being bought out by Black and White Records. (Right, photograph by William Gottlieb.)

Duke Ellington was a regular fixture in Los Angeles. With his intricate arranging and timeless melodies, he helped to elevate jazz music to the position of America's classical music. Along with his writing partner Billy Strayhorn, Ellington all but defined the big band sound. When he and his band would stay at the Dunbar Hotel, they would put the never-ending card game on hold to soak in the sounds of Los Angeles's top jazz musicians at surrounding clubs. (Courtesy of the Charlotte Bass Collection, USC Library.)

*Jump for Joy* was a full-length musical that dealt with the ideas of African American identity. Coincidentally, it premiered at the Mayan Theater in downtown Los Angeles on the same day that Jelly Roll Morton passed away. The show ran for 122 performances before closing on September 29, 1941. Although deemed a success, Duke Ellington's dream of bringing the show to Broadway never happened. Nonetheless, Ellington and his band members spent the summer of 1941 in and around Los Angeles. The show was the toast of Hollywood and featured a band that included vocalist Dorothy Dandridge, bassist Jimmy Blanton, blues shouter Big Joe Turner, and honey-toned vocalist Ivie Anderson.

Vocalist Ivie Anderson performed with Duke Ellington for over 10 years. She was featured on countless records throughout the 1930s, introducing songs like "I Got It Bad (And That Ain't Good)" and "All God's Chillun' Got Rhythm." Because of health concerns that derailed her singing career, she settled into a second career as a restaurant owner. Ivie's Chicken Shack was a small restaurant at 1105 1/2 East Vernon Avenue, just east of Central Avenue. Musicians like Charles Brown and Art Tatum would come by and play for customers or just for their own amusement. The small space served as an after-hours option for those still looking to make the most of their night well into the morning.

"Mood Indigo," also credited to Barney Bigard and Irving Mills, was one of Ellington's many jazz standards. Introduced in 1930, the tune was a change of pace for Ellington's ensemble. It swirled together muted horns in a way that they did not have to fight for attention amongst a ballroom full of dancers and conversation. Ivie Anderson recorded it with Ellington in 1940. Within three years, she had left the ensemble. (Courtesy of the Quincy Inara Music Collection.)

Ivie Anderson lived in a modest house along a row of Craftsman homes at 724 East Fifty-second Place, just west of Central Avenue. The small home was a short walk to her restaurant where Anderson regularly held court and chicken wings. Chronic asthma, which had already sidelined her singing career, finally took her life in 1949 when she was only 44 years old. Her block is now known as the 52nd Place Historic District and was listed in the National Registry of Historic Places in June 2009.

# The Downbeat

### 4201 So. Central Ave. - Los Angeles

The Downbeat was a narrow bar just north of the Dunbar Hotel at 4201 South Central Avenue. Bandleader Gerald Wilson was one of the first to play the venue, which was supposedly owned by Hal Stanley and Elihu McGhee; however, there are conflicting stories about who had their name on the deed. Alto saxophonist Buddy Collette recounted that a regular fixture at the bar was famed mobster Mickey Cohen. Cohen was more than just a jazz fan: his signature was on the checks that the bandleaders received. Cohen had his hand in many nightlife spots, so his involvement in showgirls and liquor down on the avenue should not be too much of a surprise. In the 1940s, he was at the top of his power with a hand in anywhere profitable throughout the county. (Above, courtesy of the Quincy Inara Music Collection.)

The Elks Hall was a sprawling venue located at 4016 South Central Avenue. Although it was not known to have particularly good acoustics, it still hosted a nice night out for large crowds. Gerald Wilson regularly brought his big band there, and artists like Count Basie and Big Jay McNeely were happy to play the space. The fifth of July concert advertisement (below) boasts of the "hottest jam session in town," which was quite a boast considering that every venue within five square feet of the bandstand was happy to let legends like Charlie Parker and Dexter Gordon entertain their customers for free. (Right, courtesy of the Charlotte Bass Photo Collection, USC Library; below, courtesy of the Quincy Inara Music Collection.)

**HOTTEST JAM SESSION IN TOWN—MIDNITE ON**

# LET 'FREEDOM FLING'

### DANCE — SATURDAY — JULY 5th
— 8:30 On —

- 12-Piece Unity Band
- Fun, Refreshment, Friendliness
- Spirit of '76 Decorations

**Elks Hall**      4016 S. Central      Los Angeles
(Auspices L. A. Communist Party)      Tickets on Sale $1.20 (tax incl.)

Club Congo was located on the same block as the Dunbar Hotel. It was another of many nightlife options that catered to the middle class. Drummer Al "Cake" Wichard is seen below playing with his eight-piece ensemble on the Congo's tastefully adorned stage. Although the Central Avenue scene was competitive, there were a lot of opportunities for artists who could put on an entertaining show.

Club Alabam, located at 4215 South Central Avenue, was in the middle of it all. The crowds got dressed up, enjoyed steak dinners, and were witness to a full show of bands, comedians, and showgirls. It was the centerpiece of the Central Avenue block near the Dunbar Hotel. Bandleaders Harlan Leonard, Roy Milton, and Johnny Otis all served residencies at the famed venue and brought one of the most elaborate stage shows possible to the avenue. (Courtesy of the Shades of LA Collection, Los Angeles Public Library.)

Movie stars like Humphrey Bogart and Orson Welles (pictured at left) came down to Central Avenue to "slum it." Welles eventually became a big proponent of the Dixieland and New Orleans jazz sound. He was a key part in getting Kid Ory out of retirement and frequently featured Ory on his Mercury radio broadcasts. (Photograph by Carl Van Vechten.)

47

**Newly Decorated**
**Club AlabaM**
announces

5th Anniversary Celebration
Friday, November 15th, 1935

Stars of
SCREEN · STAGE · RADIO
in person

2 All-Star Floor Shows 2
STAGED AND CONCEIVED BY DICKIE WALKER

Capable 28 Artists

Dickie Walker        Ernestine Porter
Eddie Anderson      Betty Treadville
Johnny Taylor          Lillian Randolph
The "3" Rockets      Bill Hollis, M.C.

and those Dancing Creole Beauties
with
LORENZO FLENNOY
and his orchestra

Bes and Pete Rizzotto, Managers
4015 S. Central Ave.        Phone ADams 9092

The advertising materials for Club Alabam proudly promote "your genial host Curtis Mosby." It was smart branding for the neighborhood that capitalized on Mosby's reputation and decadence, a stamp of quality for the nightclub crowd. The advertisers also make a point of linking themselves with the biggest African American neighborhood in the country by proclaiming themselves the "finest Harlem café in America!" What must Harlem have thought of that claim?

2 SHOWS NIGHTLY

**NEW CLUB ALABAM**

42nd & CENTRAL AVENUE

*Finest Harlem Cafe in America!*

*Your Genial Host Curtis Mosby*

48

The Last Word was a more modest venue located across the street from Club Alabam at 4206 South Central Avenue. Curtis Mosby's younger brother Esvan, who also served as an honorary mayor of Central Avenue, owned it. It was another major player in the thriving nightclub scene concentrated on that small strip of Central Avenue. The phrase "Smartest Sepia Night Club" aimed at a sophisticated crowd, drawing blues and jazz musicians to their bandstand.

49

Boxer Jack Johnson, heavyweight champion of the world, was an African American hero. Miles Davis proudly named his 1971 electrified album after him. More importantly, Johnson was a neighborhood hero. He ran a club inside the Dunbar Hotel for several years and was a flamboyant presence on the avenue. Amongst the jazz musicians and movie stars, he, too, was royalty. (Courtesy of the Quincy Inara Music Collection.)

Ernest Bendy, better known as boxer Dynamite Jackson, was also a local entrepreneur. His career in the ring lasted less than 10 years, but he held onto a respectable record of 46-14-0. He opened a club appropriately called Dynamite Jackson's. It was located further south from the Dunbar Hotel at 5501 South Central Avenue near other blues venues (like the Atlantic Club at 5259 South Central Avenue and the Paradise Club at 5505 South Central Avenue).

Multi-instrumentalist Benny Carter was a bit of an elder statesman to the bebop kids. He formed his first big band in the late 1920s and was a consummate arranger for himself and others, including bandleader Tommy Dorsey and vocalists Billy Eckstine and Mel Torme. He was also a mentor to younger musicians like trumpeters Miles Davis and Quincy Jones, who saw his success as something to aspire to. (Photograph by William Gottlieb.)

Benny Carter's biggest hit came in the 1930s with "Cow-Cow Boogie," a novelty tune appropriated for a revoltingly racist cartoon. It probably was not his shining moment as a composer, but it helped him to attract the attention of Hollywood. (Courtesy of Quincy Inara Music Collection.)

In 1943, Benny Carter moved to Los Angeles when he got his first film-scoring break on *Stormy Weather*. The film, based on the life of Bill "Bojangles" Robinson, was a black Hollywood tour de force. It also starred Lena Horne, Cab Calloway, and pianist Fats Waller. Although the resulting movie was about as racially sensitive as Hollywood was capable of in the 1940s, it featured stellar performances, memorable dance sequences by the Nicholas Brothers, and was an unparalleled opportunity for African American actors to break out of the limited roles they were being offered by major movie studios. (Courtesy of the Quincy Inara Music Collection.)

Cabin in the Sky was happy to employ the same successful formula as Stormy Weather. Based on the 1940 musical of the same name, the film also featured Lena Horne, but this time she was paired with comedian Eddie "Rochester" Anderson with appearances by Louis Armstrong and Duke Ellington. The sound track included definitive renditions of Mercer Ellington's "Things Ain't What They Used to Be" and Vernon Duke's "Taking A Chance On Love." (Courtesy of the Quincy Inara Music Collection.)

Although Blues in the Night was not a successful film and did not prominently feature an African American cast, the 1941 movie did hire several musicians, including Snooky Young, to overdub Jack Carson's trumpet playing. If they were not allowed to be onscreen, many jazz musicians were hired to teach or record the sounds for white actors to mime to. It may not have been a glamorous gig, but it was good work for someone who did not crave the spotlight. (Courtesy of the Quincy Inara Music Collection.)

*Cecil Gant*
EXCLUSIVELY ON TOWN BEAT RECORDS
Los Angeles 13, California

Pvt. Cecil Gant was a World War II–era musical phenomenon. He was discovered singing at a war bond rally in Pershing Square in downtown Los Angeles and ended up with a recording contract. His sad but dreamy "I Wonder" featured only his distinct droopy vocals and sparse piano fills. The tune was perfect for that lonesome GI longing for a familiar touch. Gant latched onto the Army connection, regularly performing in khakis, and the result was a number one R&B hit in 1944. He died seven years later at the age of 37.

Bulee "Slim" Gaillard had a fantastical background story involving childhood labor picking bananas in Cuba before being left behind in Crete by his father. He was a hipster mystery and a regular character on Central Avenue. Along with bassist Slam Stewart, Slim had several hits, including "Flat Foot Floogie" and "Cement Mixer," a lackadaisical tune released in 1945. Many of the lyrics, including the parenthetical end of the title "Put-Ti, Put-Ti," sprung from Gaillard's goofy invented patois. (Above, courtesy of the UCLA Photo Library; left, courtesy of the Quincy Inara Music Collection.)

Gaillard was nice enough to transcribe his secret language for those looking to get on the right side of hip. He called his language "Vout" and freely peppered it into his songs and stage patter. This handy little guide was probably useful for those trying to negotiate record contracts with him.

**Slim Gaillard's VOUT-O-REENEE DICTIONARY**

— D —

| | |
|---|---|
| DAVID | Beard |
| DEVIL-DINNER | Fire |
| DIGESS-VOOTY | Book |
| DIG | Think; Understand |
| DIG YOU | See you later |
| DIP-DIP | Ink |
| DIP-DIP-RE-FILL | Inkstand |
| DRUG-O-RE-NEE | Sad |
| DRY-DUS | Morning |

— E —

| | |
|---|---|
| EE-NAH | Child |
| EGG-SUPP | Hen |
| EYE-EZEE | Admire |

— F —

| | |
|---|---|
| FALL-H-TWENTY | Waterfall |
| FENCED IN | Marriage |
| FIDDLER | Cat |
| FLICKER-E-NEE | Theatre |
| FLY-FU | Bird |
| FLY-STAY | Kite raise |
| FOO-ER-E-NEE | Market |
| FOOT | Hand |
| FOUR GE-HEN-GEE | Animal |
| FRAME STASHER | Bed |
| FRAY-GRAY | Perfume; Lotion |
| FULL DRESS | Evening |

7

Chester Himes's searing 1945 novel about an African American ship worker trying to live and survive in Los Angeles is still required reading. The novel daringly challenged assumptions about a unified American front during the World War II and dug deep into race relations. His main character, Bob Jones, lives and works around Central Avenue but interacts with his white coworkers in the segregated confines of the shipyard. Himes lived in Los Angeles in the 1940s while trying to find success as a screenwriter. He stated in his autobiography, "Under the mental corrosion of race prejudice in Los Angeles I became bitter and saturated with hate." His novel defines that hate, and it resonated with numerous generations, providing a much needed alternative to the prevailing propaganda of harmony. After encountering more than enough roadblocks in America, he moved to France. He found commercial success with a series of eight Harlem detective novels based around the characters Gravedigger Jones and Coffin Ed Johnson.

On December 7, 1941, the world changed. Some worlds were more drastically affected than others. Japanese communities across America were quickly rounded up, and a propaganda machine spared no expense in alerting Americans to the perceived threat of every single Japanese person, regardless of age or intent. The enemy had a face, and Hollywood and the defense industry were eager to distort it. The result was a series of Asian caricatures by defense corporations like the Douglas Aircraft Company and paranoid Hollywood productions, including *Little Tokyo USA*, which revolved around the small neighborhood of Little Tokyo (centered around the intersection of Central Avenue and First Street in downtown Los Angeles).

Regardless of age, gender, or intent, the Japanese in America were systematically locked up in rural camps. They were given little time to sort their possessions or secure their property. In Los Angeles, the result of this internment was a multitude of vacant homes and shops at the northernmost end of Central Avenue. Although 8,000 Japanese residents were shipped out, 30,000 African Americans quickly filled their space. Central Avenue had been overflowing with residents when new jobs from World War II drew African Americans from every corner of the country. For a few years, Little Tokyo became known as Bronzeville before eventually reverting back to a Japanese neighborhood. (Photograph by Clem Albers.)

Located at 204 1/2 East First Street, the Kawafuku Japanese restaurant was a long-running business in Little Tokyo. When the Japanese were evacuated, Bronzeville changed the purposes of some of the business fronts. Kawafuku became Shepp's Playhouse, an extravagant jazz venue that boasted some of the best Central Avenue talent. When the evacuation orders were lifted, the neighborhood returned to the Japanese and Kawafuku reopened, becoming notable for introducing sushi to American eaters in the early 1960s. (Below, courtesy of the Quincy Inara Music Collection.)

Shepp's was the place to see and be seen. The club adopted many of the formats of the successful Central Avenue clubs like Club Alabam, including dancing girls and Bardu Ali's orchestra (who were regulars at the Lincoln Theater). T-Bone Walker, who had electrified the avenue, was quick to plug his guitar into Shepp's wall. In the shadow of Los Angeles City Hall, the nightlife surged in the tiny district. (Courtesy of the Quincy Inara Music Collection.)

Other jazz clubs popped up in the neighborhood as well. Trumpeter Howard McGee ran the Club Finale, which regularly featured Charlie Parker in the mid-1940s. While the Cobra Room hosted jam sessions and boasted of the temperature of their beverages, places like the Palms introduced the idea of a "breakfast club." Breakfast clubs were nightclubs that were open in the morning. The 24-hour defense industry was releasing workers at all times of day, and they had cash in their pockets; it would have been foolish not to offer them an opportunity to trade that cash for some new sounds. (Courtesy of the Quincy Inara Music Collection.)

Joe Liggins's "The Honeydripper" is still one of the most played hits to come out of Central Avenue. The simple tune and lyrics spent 18 weeks at the top of the R&B charts. The demand was so high that Liggins's label, Excelsior, was unable to keep up with production of new discs. It was replaced on the charts by Jimmie Lunceford's version of the same tune. Lunceford had the power to keep up with an audience that was eager to hear the new tune and not, necessarily, the performer. (Courtesy of the Quincy Inara Music Collection.)

The dispute over who wrote "Open the Door, Richard" was a contentious one. "Pigmeat" Markham was one of several comedians who claimed to have invented the gag, but it went well beyond the song's 1946 release date. Cheech and Chong even found success with the joke 30 years later. Nonetheless, Jack McVea gets the credit for the pop hit on the local label Black & White. Count Basie, Dusty Fletcher, and the Three Flames all found later success with the same tune, mining the punch line for all its exasperated glory. (Courtesy of the Quincy Inara Music Collection.)

Alto saxophonist Charlie "Bird" Parker came to Los Angeles for a five-week engagement in 1945 and ended up staying for over a year and a half. In that time, he recorded some of his greatest music, suffered through immense heroin withdrawals, and served six months in a mental institution after lighting his Bronzeville hotel room on fire. He was the king of bebop when he arrived, and many of the younger musicians did anything they could to get close to him. Parker played regularly with pianist Hampton Hawes and trumpeter Howard McGhee, who helped to nurse him back to health. Saxophonist Big Jay McNeely proudly recounts that he got his mom to wash Bird's laundry. Thanks to McGhee, bebop was already spoken fluently in Los Angeles, but Parker gets credit for introducing the sounds. It is more likely Parker helped them refine their accents and served as example of what not to do with one's life off the bandstand. (Photograph by William Gottlieb.)

Record shop owner Ross Russell started Dial records solely to record Charlie Parker while he was in Los Angeles. Numerous sessions for the label resulted in some of Parker's most creative exploits as well some of his inebriated lows. Russell also managed to record several other bop legends for his label, but when Bird went back to New York in 1947, Russell followed him to continue preserving his melodic innovations. Russell eventually wrote a biography of Parker entitled *Bird Lives* that helped to immortalize Parker's self-destructive reputation. (Right, courtesy of Armand Lewis; below, courtesy of the Quincy Inara Music Collection.)

Tenor saxophonists Dexter Gordon and Wardell Gray regularly sparred at Jack's Basket Room. Their tenor battles were legendary, travelling to the Elks Hall and out to Pasadena's Civic Auditorium. Their unhinged tenor wars spurred something primal in their young audiences that is evident on recordings like "The Chase" and "The Hunt," which Ross Russell managed to get down on tape. The studio versions were thrilling, but nothing could compare to the energy generated by the young audiences. (Courtesy of Armand Lewis.)

Jack Kerouac was one of those enamored with the primal push of the two horns, and he summoned their beatnik ethos in his classic novel *On The Road*. "They ate voraciously as Dean, sandwich in hand, stood bowed and jumping before the big phonograph, listening to a wild bop record I had just bought called *The Hunt*, with Dexter Gordon and Wardell Gray blowing their tops before a screaming audience that gave the record fantastic frenzied volume."

# WAY OUT WARDELL

MODERN RECORDS

Wardell Gray was only 25 years old when he left Earl Hines's orchestra to settle in Los Angeles. He took to the avenue with his horn and made a name for himself on the stages of the Downbeat, Jack's Basket Room (3219 South Central Avenue), and Lovejoy's. He was forever linked to long, tall Dexter Gordon because of their riotous tenor battles. Gray eventually took steady work with Count Basie and Benny Goodman before reaching a suspicious demise in the Nevada desert. He was only 34 and due to play the Moulin Rouge in Las Vegas with Benny Carter's band. Gray made it to the rehearsal but did not show up for the gig. He was found the next day, just outside of the city, dead with a broken neck.

**WRIGLEY FIELD**
me of the Los Angeles Baseball Club, P. C. L.
Opening Day Sept. 29th, 1925.
Rogers Airport Photo.

Chicago's famed Wrigley Field was not the only baseball stadium named after chewing gum magnate William Wrigley Jr. One avenue west of the Dunbar Hotel, from 1925 to 1969, another Wrigley Field served Los Angeles's stadium needs. The two-tiered, 22,000-seat behemoth was home to the Los Angeles Angels and their rival, the Hollywood Stars. When baseball games were not being held, the stadium was frequently used for Hollywood, serving as the baseball field for the film *Damn Yankees* as well has hosting television shows like *The Twilight Zone* and *The Munsters*. Once a year, it was also the site of the Cavalcade of Jazz. One Sunday in July, the dugout was filled with jazz fans as bands set up on the diamond, including big-name acts like Louis Armstrong and Big Jay McNeely. The idea of a jazz show taking over a stadium is almost inconceivable now; however, before it moved closer to downtown to the Shrine Auditorium, the Cavalcade of Jazz was a welcome event at the stadium from the 1940s through the 1950s.

Bebop trumpeter Dizzy Gillespie is seen here with his big band at the ninth annual Cavalcade of Jazz. The ebullient showman was a great ambassador for the bebop movement. His puffed out cheeks, wild eyes, and skyrocketing trumpet managed to both entertain and advance the art form. What other jazz musician could be a good fit for the Muppets? (Courtesy of the Oviatt Library, California State University Northridge.)

An unidentified saxophonist riles up the crowd, honking in his tuxedo atop a table at the 11th annual Cavalcade of Jazz. This was a brief glittering moment of jazz as straight-up entertainment before the music was bogged down by academia and oppressive seriousness. Jazz was once the music of the people, and an element of entertainment value was not just provided: it was expected. (Courtesy of the Oviatt Library, California State University Northridge.)

Los Angeles–born jazz promoter Norman Granz was many things to the jazz community. Aside from his work as a manager for Ella Fitzgerald and as a record producer (he created the Clef, Norgran, Down Home, Verve, and Pablo labels), he helped to introduce many musicians to the wider public with his famed Jazz at the Philharmonic series. The first Jazz at the Philharmonic concert was held on July 2, 1944, at the famed Civic Auditorium (across the street from Pershing Square and less than half a mile from the tail end of Central Avenue). Before it upgraded to the Dorothy Chandler Pavilion and then the Walt Disney Concert Hall, the Civic Auditorium was the luxurious home to the Los Angeles Philharmonic for 44 years. The conservative classical venue was not quite prepared for the raucous jazz crowd that filed in, and the concerts eventually moved elsewhere. (Left, photograph by William Gottlieb.)

Jazz at the Philharmonic, or JATP as it became known, quickly turned into a springboard for artists like Nat King Cole, guitarist Les Paul, and pianist Oscar Peterson. The series ran for nearly 40 years, building to a touring brand that extended to Europe and Japan. Granz's work was notable for boasting an integrated band wherever they played, regardless of the pushback he received from venue owners. Old hands, like saxophonist Ben Webster and trumpeter Roy Eldridge, were paired up in informal jam session settings with young guns like trombonist J.J. Johnson and bassist Ray Brown. Many of the first few concerts pooled their talent from the clubs of Central Avenue. This program was one of many produced for the relentless touring show, which set out seasonally to conquer box offices. (Courtesy of the Quincy Inara Music Collection.)

**The MUSICIANS' ASSOCIATION OF LOS ANGELES**
*Proudly Presents*
**THE OFFICIAL DEDICATION**
*of its*
★ **NEW BUILDING** ★
Saturday, January 21, 1950

*We dedicate this beautiful building not only to the advancement of music and musicians, but dedicate ourselves, as well, to that unity of purpose that alone safeguards our gains, through unselfish service to our Local, our great American Federation of Musicians, and to the wonderful community in which we live.*

There were two musicians unions in Los Angeles for decades. The segregated workforce was not as united as their mission statement may have liked. Known as the black musicians union, Local 767 was housed at 1710 South Central Avenue. Under the watchful gaze of business agent Elmer Fain, the Local 767 was a powerful source of employment on Central Avenue. Being a card-carrying member of the musicians union was an essential tool to finding employment as union-sanctioned gigs were rigorously protected and well compensated.

Union head James Petrillo wielded considerable power during his tenure from 1940 until 1958. His most influential acts were two separate recording bans, one from 1942 to 1944 and another in 1948. These bans effectively shut down the market for new recordings and forced a deal for higher royalties. Artistically, this was devastating because many great bands came and went without being preserved. However, it was a financially bold statement that is virtually inconceivable today.

Brothers Lee (right) and Lester Young (below) were two sides of a coin. Lee worked with the Ellington and Basie big bands and contributed rhythmic work to thousands of records. His reliability got him steady work in the competitive studio scene. He famously taught actor Mickey Rooney the finer points of jazz drumming. Lester was the more famous and self-destructive brother. He too played with Basie's band, fitting in nicely with his relaxed, contemplative tone. Lester helped to define a place for the tenor saxophone before the bebop era. His sleepy look matched his sound on recordings alongside artists like Billie Holiday and pianist Teddy Wilson. Not yet 50 years old, he succumbed to a life of alcohol abuse in 1959. Both Lee and Lester lived around Central Avenue for many years, and Lee spent the bulk of his life in the area. (Right, courtesy of the Charlotte Bass Collection, USC Library; below, photograph by William Gottlieb.)

Coleman Hawkins was the other master saxophonist stomping around the Central Avenue scene in the 1940s. His bold sound was a link between the big bands and the beboppers. Miles Davis, pictured sharing the bandstand with a mid-solo Hawkins, toured with him and stated, "When I heard Hawk, I learned to play ballads." Famed jazz saxophonist Charles Lloyd, who arrived in Los Angeles during the waning days of Central Avenue, tells a story about Hawkins's tendency to forget his saxophone in the backseat of his unlocked car after a night out. A prime example of the respect and environment at the time, Hawkins's horn was always there when he returned. (Photograph by William Gottlieb.)

Trumpeter Howard McGhee was Charlie Parker's California liaison in the late 1940s. McGhee had a lightning-quick bebop sound and was prominent on Central Avenue and in Bronzeville. Many of his greatest recordings were done for the Dial label before he was sidelined by a drug addiction for much of the 1950s. (Photograph by William Gottlieb.)

Pianist Hampton Hawes was only a teenager when he first played with Charlie Parker. The Los Angeles–born musician quickly made a name for himself with his intricate phrasing and quickness on the 88, recording indispensible trio albums in the 1950s for the Los Angeles–based Contemporary label. His jazz autobiography is one of the greatest ever written, recounting his playing time as well as his incarceration and subsequent pardon from Pres. John F. Kennedy.

77

The phrase "modern afro-american jazz" may not cause records to fly off the shelves, but, as an artistic statement, it helps to establish what the artists were intending with their compositions and performance. Featuring pianist Gerald Wiggins, drummer Chico Hamilton, and guitarist Jim Hall under the leadership of multi-reedist Buddy Collette, this LP was a who's who of the Central Avenue scene. The obscure record label Dig was run by Johnny Otis. (Courtesy of Armand Lewis.)

As is evident by her album title, alto saxophonist Vi Redd is a Charlie Parker disciple. Redd was born in Los Angeles to bandleader Alton Redd (of the aforementioned Hotel Somerville mezzanine). After a break from performing in the late 1950s, she had a long career off the avenue with Count Basie's band and the Earl Hines orchestra, out swinging her male contemporaries while also showcasing a soulful singing voice that could bring a house down.

Tenor saxophonist Teddy Edwards was another musician to lock horns with Dexter Gordon at jam sessions around the avenue. Their recording entitled "The Duel" was a hit in the same style of "The Hunt" and helped bring Edwards national recognition. From a trivia standpoint, Edwards was one of a very select group of musicians to have shared a stage with Charlie Parker and Tom Waits. He continued playing until his passing in 2003.

79

Alto saxophonist Sonny Criss was a local bebop hero. His fast swinging horn was at home on Central Avenue. He played with bandleaders Johnny Otis and vocalist Billy Eckstine before linking up with Norman Granz in the late 1940s. The under-recorded saxophonist made a few records in the 1950s and 1960s, but he took his own life at the age of 50 after a difficult battle with stomach cancer in 1977.

Los Angeles–born alto saxophonist Art Pepper was the underfed white kid hanging out on Central Avenue in the early 1940s. He found success as a featured performer with Stan Kenton's band but soaked up much of his knowledge on the avenue. Before drugs and incarceration severely derailed his promising career, he recorded numerous small band records in the 1950s that highlighted his musical prowess. His autobiography *Straight Life* is another essential jazz tale of swinging hardship. (Photograph by William Gottlieb.)

Pianist and vocalist Nellie Lutcher, the eldest of 15 children, made a splash in Los Angeles in the late 1940s. Following in the footsteps of Nat King Cole, she released a handful of singles on the Capitol Records label. Her confident, swinging piano skills hold a unique place among vocalists. She could carry the band from the piano bench while her voice held a playful, complimentary air. (Courtesy of the Quincy Inara Music Collection.)

Multi-reedist Buddy Collette was one of the most significant artists to come out of the 1940s Central Avenue jazz scene. His persistence in integrating the union while also maintaining a respectable string of releases under his leadership was essential for the good of the community. He was one of the first African American television orchestra musicians appearing with the band on Groucho Marx's *You Bet Your Life*. His band, the Stars of Swing, was one of the most legendary ensembles to come out of Central Avenue without a record under their arm. Featuring bassist Charles Mingus, trombonist Britt Woodman, and tenor saxophonist Lucky Thompson, the individual band members went on to help define the sound of jazz for decades. Unfortunately, aside from rocking the walls of the Downbeat club, their music will never be heard again. (Courtesy of the Shades of LA, Los Angeles Public Library Collection.)

Tenor saxophonist Lucky Thompson frequently gets the credit for the disbanding of the Stars of Swing. He brought his bold sound to multiple Charlie Parker Dial sessions and later paired up with Miles Davis for 1954's *Walkin'*. While still living in Los Angeles, Thompson was an integral member of the Stars of Swing. The legend goes that the group began to splinter when the band arrived for a gig at the Downbeat only to see Thompson's named listed as the bandleader and no mention of the other band members elsewhere. At the time, Thompson was a bigger draw than Mingus or Collette, but the desire to work as a unit had already moved beyond repair. (Right, photograph by William Gottlieb; below, courtesy of Armand Lewis.)

The International Sweethearts of Rhythm were an all-girl band that reached their peak touring the country in the 1940s. The 16-piece rotating roster regularly played venues like the Apollo Theater in New York and the Howard Theater in Washington, DC, building up a strong enough reputation to engage in band battles with the likes of Fletcher Henderson and Earl Hines. During a one-week stay at downtown's Million Dollar Theater, several local musicians briefly joined them on the bandstand. (Courtesy of the Quincy Inara Collection.)

"Trumpetiste" (a self-applied term) Clora Bryant was one of those who joined the International Sweethearts of Rhythm in the late 1940s. She moved to Los Angeles when her father got a job at UCLA and quickly made a name for herself on the avenue. Despite the prevalent sexism of the jazz circuit, Bryant shared the bandstand with beboppers Charlie Parker and Dizzy Gillespie. Her album *Gal with a Horn* was one of only a few straight-ahead small jazz combos led by a woman.

Trombonist Melba Liston was another member of the female jazz scene in Los Angeles. While still a teenager, she joined Gerald Wilson's big band before joining Dizzy Gillespie's. She worked regularly through the 1940s before calling it quits. Liston made her lasting legacy as an arranger. She helped create early charts for Basie and Gillespie before forming a lasting working relationship with pianist Randy Weston, helping to intricately arrange his tunes throughout the 1960s.

Drummer Roy Porter was a bebop man. He played on Charlie Parker's Los Angeles recording sessions and also backed Howard McGhee. In 1949, his little-recorded big band, The Reboppers, took off with help from trumpeter Art Farmer, saxophonist Eric Dolphy, and trombonist Jimmy Knepper. A near-fatal car accident while on tour in Texas put Porter out of commission for a while, and the band was never able to recoup its losses. Porter continued playing in and around Los Angeles until his passing in 1998, but he never reformed his 17-piece band.

Trumpeter Art Farmer, along with his twin brother Addison, moved to Los Angeles in high school. As a teenager, he took numerous big band gigs, augmenting the brass section of Johnny Otis and Jay McShann's band. In the 1950s, he set out for New York and made a name for himself with smaller ensembles, including his legendary pairing with tenor saxophonist Benny Golson in the Jazztet.

**CONTEMPORARY**
**STEREO S7550**

# Grooveyard
# Harold
# Land
### Quintet

Tenor saxophonist Harold Land made his biggest splash as a member of the machine-gun ensemble known as the Clifford Brown/Max Roach Quintet. He was replaced by Sonny Rollins when he made the move to Los Angeles in the mid-1950s. The iconic *Grooveyard* cover was shot in 1958 and featured the recently completed Watts Towers (located 60 blocks to the south of the Dunbar Hotel). The one-of-a-kind sculpture took over 30 years to complete but is still standing, a beacon of artistry in the heart of Watts. The hard-swinging album also featured the last performance by the promising young pianist Carl Perkins. Land spent his later years as a jazz professor at UCLA, imparting a rigorous regiment for the mastery of the standard songbook.

Jazz musicians were not always chain-smoking intellectuals. There was a space for goofiness, and this photograph best exemplifies some of the fun these musicians had. Trumpeter Gerald Wilson, eyeing the camera in a sharp suit, is joined by guitarist Irving Ashby, bassist Red Callender, drummer Lee Young, and pianist Phil Moore. All of these musicians were regular performers along Central Avenue, supporting countless acts for the benefit of the eager crowds. (Courtesy of the Shades of LA collection, Los Angeles Public Library.)

Gerald Wilson, who was still teaching UCLA's jazz history course into his 80s, used to declare to his students about any jazz history book, "If I'm not in it, it's not worth buying." The charming writer/arranger got his start in 1939 playing with Jimmie Lunceford's band. His use of dense harmonies made him an in-demand arranger for artists like Ray Charles and Sarah Vaughan as he forged his own solo career as a bandleader, educator, and radio host. He was nominated for a Grammy at age 93. (Above, courtesy of the Charlotte Bass Collection, USC Library.)

Vocalist Ernie Andrews has been singing along Central Avenue for nearly 70 years. The crooning tenor made a name for himself singing with bandleader Harry James before attempting some solo hits with Columbia Records. Although he never stopped performing, his career hit a decade-long lull before being revived in the 1980s. Now in his mid-80s, he can still hold those long notes and get the ladies to swoon like it was 1947 all over again. (Courtesy of the Charlotte Bass Collection, USC Library.)

Saxophonist Frank Morgan was slated to be the heir to the Charlie Parker throne. The son of guitarist Stanley Morgan, Frank moved to Los Angeles as a teenager and made a name for himself on Central Avenue. A relentless heroin addiction sidelined him for years after he recorded his debut. He ended up serving time in San Quentin prison in the 1960s at the same time as Art Pepper, and the two played together while incarcerated. Morgan did not hit his stride until he had cleaned up in the 1980s, and he played and recorded until his passing in 2007.

**the CHARLES MINGUS quintet + MAX ROACH**

fantasy 6009
HIGH FIDELITY

debut SERIES

RT GOLDBLATT

Bassist Charles Mingus was born in Watts in 1922. The temperamental innovator of the four-string upright bass played regularly on Central Avenue as well as Hollywood gigs with the likes of vibraphonist Red Norvo and Kid Ory. Those disparate experiences created a unique framework for Mingus's compositions and playing style, incorporating the bebop sounds of the avenue with the collective, chaotic improvisations of New Orleans–style bands. He became one of the most significant jazz composers of the 20th century after moving to New York and commanding top-notch ensembles for Columbia Records. Starting in 1952, he tried his hand at running a record label with his business partner, drummer Max Roach. It was a short-lived adventure that resulted in a handful of terrific recordings.

Dancer and choreographer Alvin Ailey grew up on Central Avenue. His single mother moved the family to Los Angeles in pursuit of war boom jobs in the early 1940s. He attended Jefferson High School and became interested in dance at the age of 18. Ailey incorporated many elements of African American culture into his dance pieces, applying jazz to many of his performances. He eventually became one of the most significant choreographers of the 20th century before his untimely passing in 1989. (Photograph by Carl Van Vechten.)

Los Angeles's first African American mayor, Tom Bradley (far right), learned the ins and outs of the city as a policeman on Central Avenue in the 1940s. In this picture, he is standing with several prominent African Americans, including vocalist and activist Paul Robeson (center). They were gathered to celebrate the 75th anniversary of the *California Eagle*. (Courtesy of the Charlotte Bass Collection, USC Library.)

852—Home of Eddie "Rochester" Anderson, Los Angeles, California

NBC Comedian and Screen Star

Eddie "Rochester" Anderson entered into the public consciousness by way of Jack Benny's radio and television show. The old-school African American comedian lived nearby in Sugar Hill and successfully ran for the position of honorary mayor of Central Avenue in 1940, promising to "pave Central Avenue with pancakes and flood it with molasses." He used the Dunbar Hotel as his election headquarters. Anderson continued the character of Rochester well into the 1960s, which helped him afford the palatial digs immortalized on this postcard.

"Pigmeat" Markham frequently appeared on stage at the Lincoln Theater performing his comedy routines like "Here Comes the Judge" for adoring fans in the 1920s and 1930s. He was a chitlin circuit entertainer who carried on with a blackface routine long after it was deemed socially acceptable, finding a resurgence with *Laugh-In*. Nonetheless, he was a beloved fixture on Central Avenue and revered for his success in Hollywood. (Courtesy of the Quincy Inara Music Collection.)

# Four

# Central Avenue Blues

*Going down to Los Angeles
Stroll down Central Avenue
Maybe I can find someone there
That can make me forget about you.*

—PeeWee Crayton, composer
"Central Avenue Blues"

"Chinese music" was the phrase bandleader Cab Calloway used to describe the new bebop sounds of Dizzy Gillespie and Charlie Parker. He was not alone in that belief. The intricate harmonies and breakneck speeds were not the easiest to dance to. After World War II, the united front of jazz split into numerous factions. The heady cats spiraled out into the land of Thelonious Monk, John Coltrane, and, eventually, Ornette Coleman. Those who wanted to impress their dates on the dance floor followed the sound of the electrified guitar and the honking saxophones that answered to more primal feelings. Central Avenue gladly filled with blues shouters, and homegrown record labels took advantage of the opportunity to preserve these appealing sounds. Through it all, the scene was working its way to equality. Segregated neighborhoods and musicians unions were finally starting to show cracks as a movement grew strong enough to defeat them. By the mid-1950s, Central Avenue's African American community was no longer confined to their tiny neighborhood, and those who could took full advantage of exploring their options. As a result, the scene scattered west like grains of sand towards the beach.

Between 1920 and 1950, the population of Los Angeles quadrupled. Home building boomed, and pavement was laid down in every direction imaginable. The pollution increased with the population until it got to be unmanageable. Smog blanketed the city as unfiltered mufflers spewed toxic fumes into the air, and the once pristine beaches were covered in garbage in the shadows of leaky oil derricks. The city was unable to handle such rapid growth, and it took decades to right the ship.

Record stores were plentiful on Central Avenue, but none were more famous than John Dolphin's Dolphin's of Hollywood at 1065 East Vernon (less than one block west of Central Avenue). The term "Hollywood" was clearly used loosely and was meant to apply a touch of glamour to Dolphin's entrepreneurial aspirations, which stretched to every corner of the music business. (Courtesy of the Charlotte Bass Collection, USC Library.)

Los Angeles loved their radio personalities, and Huggy Boy was one of the most prized. He was a key component in promoting R&B and rock and roll as far as his microphone could reach from the front window of Dolphin's shop on station KRKD. He got involved in record production for Dolphin's subsidiary labels, eventually finding his niche with the Chicano rock movement happening not far from Central Avenue in East Los Angeles in the 1950s and 1960s. (Courtesy of the Quincy Inara Music Collection.)

John Dolphin was a well-known businessman. He ran several labels, including Dolphin's of Hollywood, Recorded In Hollywood, and the more straight to the point Cash and Money. He not only captured jazz musicians like Charles Mingus, but also aspiring R&B singers like Percy Mayfield and Jesse Belvin.

Dolphin's business dealings eventually led to his demise when he was shot in his store by disgruntled songwriter Percy Ivy over royalties in February 1958. Standing in the store at the time was future Beach Boy Bruce Johnston.

Dootsie Williams ran his Dootone Records from his home at 9514 South Central Avenue. He got his start as the leader of a band called the Harlem Dukes before deciding to get a desk rather than another baton. Although he was interested in recording music, he struck gold when he convinced comedian Redd Foxx to let him record a set and release it as an album. What followed was an avalanche of risqué party records that helped Redd Foxx sell a lot of albums that few people were willing to admit they owned.

Scatman Crothers, best known for his roles on *Chico and the Man* and in *The Shining*, was another local comedian who recorded an album for Dootsie Williams in the early 1960s, helping to launch the comedy record boom.

Dootsie Williams only released a few straight-ahead jazz records, but those that he put out were immensely important to the history of the Central Avenue jazz scene. Los Angeles–born tenor saxophonist Dexter Gordon's *Dexter Blows Hot and Cool* captured the tenorman without any other tenor competition. Here, Gordon worked through a series of standards with a tight quintet in 1955. (Courtesy of Armand Lewis.)

A few years later, the label released one of Buddy Collette's earliest albums sharing a frontline with Gerald Wilson on trumpet. (Courtesy of Armand Lewis.)

Upright bassist Curtis Counce and pianist Carl Perkins were two Los Angeles–based artists who died far too young. Counce's goofy space getup on his album *Exploring the Future* anticipated a nationwide interstellar fascination. He had also been a member of Johnny Otis's band and made his recording debut with Lester Young.

Carl Perkins had a unique style of playing because of a crippled left hand (a consequence of polio). He perched it sideways along the keyboard for good effect while releasing bop lines with his right hand. Perkins died of a drug overdose at the age of 29.

101

Jazz LPs were never going to make Williams successful. The turning tides of the 1950s record-buying audience clearly intended for jazz to go one way while sales were going elsewhere, primarily higher and wider. Doo-wop and R&B began to overtake Central Avenue with the electric guitar stealing the spotlight from trumpeters and big band leaders. "Earth Angel" was Williams's gold mine. Released as the B-side to the Penguins' *Hey Senorita* in 1954, the song reached the top 10 in both pop and R&B charts. The song instantly became a doo-wop standard and helped keep the lights on for Dootone for years to come. (Courtesy of the Quincy Inara Collection.)

Johnny Otis was one of the preeminent personalities on the avenue. He was a Renaissance man who had his hand in everything: he led a band at the Club Alabam, he was a sculptor and a disc jockey, he discovered vocalist Etta James, he hosted a television show, and he had his own line of apple juice. In 1958, Otis struck it big with his own hit entitled "Willie and the Hand Jive," a clave groove that is still the basis for many modern pop songs. Otis lived into his 90s pursuing his whims. His son Shuggie became an R&B star in the 1970s.

Watts native and tenor saxophonist Big Jay McNeely started out as a straight-ahead jazz cat. He made his first recordings with Johnny Otis, who ran a club in Watts called the Barrelhouse. McNeely was a regular in the clubs of Central Avenue when he discovered that a little showmanship went a long way. He took to crawling across the bar and screeching out into the street to entertain crowds and was arrested one time in San Diego for disturbing the peace. As it was before the days of wireless microphones, his band could not hear that he had stopped playing and continued on for minutes, unknowing that the law was putting an end to his solo break. In the late 1940s and early 1950s, McNeely had several chart hits, including "Deacon's Hop," "Nervous Man Nervous," and "3-D." Even into his 80s, McNeely is still strutting out into the crowd, sitting on audience members' laps, and covering his saxophone in blacklight paint.

Texas-born blues guitarist and vocalist Aaron Thibeaux "T-Bone" Walker was extremely successful toting his guitar along Central Avenue. The energetic entertainer was known to drop into splits mid-solo. He recorded several hits for the Black & White label in the 1940s, including "Call It Stormy Monday (But Tuesday's Just As Bad)," which helped to raise his profile for gigs in the 1950s. He stood at the forefront of rock and roll with his electric guitar and relentless showmanship. (Both, courtesy of the Quincy Inara Collection.)

After Joe Liggins had tremendous success with "The Honeydripper," he continued to move his music towards radio-friendly sounds with a solid danceable beat. He signed with Specialty Records in the 1950s, finding success with tunes like "Boom-Chick-A-Boogie" and "Pink Champagne," a pleasant blend of doo-wop, blues, and boogie-woogie. (Courtesy of the Quincy Inara Music Collection.)

In the 1930s, singer Roy Milton moved to Los Angeles and started his group the Solid Senders. It was not until 15 years later, from the late 1940s into the early 1950s, that he found recording success with 19 top-10 R&B hits, including "Information Blues" and "Best Wishes." The success of these recordings in turn helped Specialty Records become one of the biggest Los Angeles–based R&B record labels. (Courtesy of the Quincy Inara Music Collection.)

Blues shouter Jimmy Witherspoon first came to prominence with Jay McShann's band in the mid-1940s. "Ain't Nobody's Business" put him on the map in 1949, and he continued with a trail of hits like "No Rollin' Blues" and "Big Fine Girl." He had peaked by the late 1950s, surrounding himself with a roster of jazz veterans for a live album at the Monterey Jazz Festival in 1959. Witherspoon continued making appearances until his passing in 1997.

Texas blues slinger Pee Wee Crayton moved to California in the 1930s and settled in Los Angeles in the 1940s. One of his R&B band's saxophonists, Ornette Coleman, followed to blaze a completely different path into the free jazz stratosphere. Crayton helped popularize the Fender Stratocaster guitar in the 1950s and had a smattering of chart-place blues tunes like "Central Avenue Blues," a sweet blues with a searing guitar solo.

Blues vocalist Big Joe Turner took part in Duke Ellington's *Jump For Joy* but ended his career a long way from long-form jazz concerts. Throughout the 1940s, he recorded with other piano greats like Meade Lux Lewis and Art Tatum. His tune "Blues on Central Avenue" was a mid-tempo homage to sunshine and temptation. In 1954, "Shake Rattle and Roll" completely changed his career around, making him an early rock and roll star with his fast and loose beat.

It is hard not to be likable with a nickname like "The Baron of the Boogie." Ivory Joe Hunter was an R&B star in Los Angeles, playing with the Three Blazers while dabbling in record label ownership. Hunter's biggest hit came in 1956 with "Since I Met You Baby," which catapulted beyond the jazz and R&B world—none other than Elvis Presley covered a handful of his tunes in the late 1950s.

Blues journeymen Eddie Mack (left) and Gene Phillips (right) smile for the camera while flanked by five bemused women. Behind them is a poster for a beauty contest at the Elk's Auditorium. This was a typical scene for the Central Avenue blues crowd, with endless promotion and signed glossy photographs demanded in order to make a living. There were countless blues artists trying to make their way on Central Avenue, and many of them are lost to time. Even those who followed the trends were not guaranteed much more than a few singles; at least these two guys looked fashionable while doing it. (Courtesy of Charlotte Bass Collection, USC Library.)

Songwriter Percy Mayfield moved to Los Angeles in 1942. He continued to hone his craft, churning out blues-based songs for nearly a decade before he had a hit with "Please Send Me Someone To Love" in 1950. This greatly improved his visibility in the music community until a car accident sidelined him. He continued to record but shied away from the stage while releasing singles with Specialty, Chess, and Imperial. In 1961, Ray Charles recorded Mayfield's "Hit the Road Jack," which proved to be one of Charles's most popular performances. Mayfield continued to write for Charles, although to lesser success. He passed away a day short of his 64th birthday in 1984. (Left, courtesy of the Quincy Inara Collection.)

Blues singer Charles Brown was another Texas bluesman. The smooth crooner filled the void left by Nat King Cole when he got too big for Central Avenue. With Johnny Moore's Three Blazers and later as a solo act, Brown found chart success with tunes such as "Driftin' Blues" and the immortal holiday classic "Merry Christmas, Baby." The latter became such a staple that it is the epitaph on his headstone. (Both, courtesy of the Quincy Inara Collection.)

111

By the end of the 1940s, there was a considerable crackdown on Central Avenue by law enforcement. The questionable tactics of the LAPD were spurred by many things (depending on who is being asked), including race, money, and power. The murder of the Black Dahlia and the crimes committed by Erwin "Machine Gun" Walker encouraged the police to use whatever force they felt appropriate to control the city. Central Avenue, with its miscegenation and general nightlife revelry, became a prime target. Former police officer Charles Stoker wrote a tell-all book—*Thicker'N Thieves*, published in 1951—that highlighted the abuse of power he was witness to while in uniform. It was a scandalous exposé that rocked the city of Los Angeles and specifically the Los Angeles Police Department, leading to what has seemed like a never-ending bid for the trust of the general public. (Above, courtesy of Herald Examiner Collection, Los Angeles Public Library.)

Slauson Boulevard, south of the Dunbar Hotel, was considered the racial dividing line. Any African American looking to buy a home south of Slauson would likely be met with some angry neighbors. Physical violence and burning crosses were not out of the ordinary. Los Angeles–based attorney and future *California Eagle* owner Loren Miller represented over 100 plaintiffs looking to combat the restrictive covenants held in Los Angeles that refused home ownership to African Americans, regardless of income or status. In 1948, the landmark case *Shelley v. Kramer* was taken on by the US Supreme Court, and Miller (along with Thurgood Marshall) helped convince the court to release a ban on enforceable restrictive covenants. The legal battle may have been won, but it took an awfully long time before African Americans could feel comfortable moving to neighborhoods outside the confines of South Los Angeles. Most of those who left were wealthier, seeking more space and better educational opportunities. The result for Central Avenue was a slow draining of wealth and power from South Los Angeles as the community spread out over the county. (Courtesy of the Charlotte Bass Collection, USC Library.)

An even longer civil rights battle waged among the segregated musicians' unions. While Local 767 was faced with dwindling prospects in South Los Angeles, Local 47 in Hollywood held sway over most of the high-paying industry jobs. It was a process that took years of cajoling, politicking, and setbacks. On April 1, 1953, the members of both unions finally agreed on a merger by a narrow margin (the yes votes outweighed the no votes 1,608 to 1,375). It was a contentious issue that was led by important African American musicians like pianist Marl Young and bandleader Benny Carter. After the merger was approved, the Central Avenue union property was sold, eliminating a major meeting place for musicians on the avenue. Not only was work gone, but the employment agency had left as well. (Courtesy of the Quincy Inara Music Collection.)

*Five*

# Things Ain't What They Used to Be

*No use bein' a doubtin' Thomas,*
*No ignorin' that rosy promise;*
*Now I know there's a happy story yet to come.*
*It's the dawn of a day of glory, millennium.*

—Mercer Ellington and Ted Persons, composers
"Things Ain't What They Used to Be"

When the prosperous left, it became a lot harder to keep things together. Civil rights battles raged across America. While success was met elsewhere, South Los Angeles was ripped apart by two riots in a 30-year span. By the time the first one erupted in 1965, the musicians had already left. By the time the second riot occurred in 1992, the memories had practically left. However, great strides have been made towards preserving what remains since the riots. A few structures stand, and a Central Avenue Jazz Corridor was declared, marking the site of former glory. The biggest contribution to preserving the memory of the Central Avenue scene is the Central Avenue Jazz Festival. Held for two days every July, the festival has showcased performers who played on the street half a century ago as well as musicians from the area who continue the traditions. The streets fill with jazz fans, tents fill with artwork, and literature and representatives from various outreach programs try to reach the civic-minded folks soaking in the sounds. For two days, a glimmer of the distant past shines bright, reminding the world of Los Angeles's inimitable contributions to America's greatest original art form—jazz.

This giant guitar and saxophone greet everyone heading north on Central Avenue at Vernon Avenue. Towering above a strip mall and a Mexican restaurant, the sculptures are significant reminders of the two instruments that helped to shape the music that the entire country would eventually embrace.

In the mid-1970s, Rudy Ray Moore filmed his most notorious film, *Dolemite*, in the rundown remains of the Dunbar Hotel. The character arose from Moore's stand-up routine before transforming into this blaxpoitation classic several years later. The blend of pimps and martial arts was a popular theme at the time.

Walter Mosley's 1990 detective classic was in the mold of Chandler and Himes's detective work. The book is primarily set around Central Avenue as Mosley's protagonist, Easy Rawlins, digs himself in and out of trouble. The book was later made it into a hit film starring Denzel Washington, Jennifer Beals, and Don Cheadle. (Courtesy of the Quincy Inara Collection.)

117

In the 1990s, an attempt was made to mark the significant landmarks of the Central Avenue Jazz Corridor. The signs appear high above the sidewalks and mark locations such as the Lincoln Theater and Jack's Basket Room. Most of the signs stand guard outside of furniture stores and nail salons, protecting a history that many of the tenants are blissfully unaware of. The sign celebrating Buddy Collette remains in storage at the Dunbar Hotel.

Hometown hero Charles Mingus is celebrated with a youth arts center on the same block as the famed Watts Towers, which is around the corner from his boyhood home. Every year, a jazz festival is held in the shadow of the center celebrating the greatest composer to come out of central Los Angeles and the musical genre he helped to elevate to high art. The center offers music classes by way of the Department of Cultural Affairs.

One of the only places that continued to host regular music events into the 21st century was the Watts Labor Community Action Committee (WLCAC) at 10950 South Central Avenue. The WLCAC was founded by Ted Watkins in 1965, shortly before the riots, and continues to this day to help organize the community in any way possible. The sprawling campus features a large performance space called Phoenix Hall, which hosted concerts by such Central Avenue jazz legends as Art Farmer, Ernie Andrews, Teddy Edwards, and Big Jay McNeely. Food and dominoes were played out front as the community gathered on a monthly basis to listen, dance, and socialize.

The Central Avenue Jazz Festival began in the mid-1990s on a small stage outside of the Dunbar Hotel. In 2013, more than 10,000 people came out to hear witnesses of the glory days, like Gerald Wilson, and keepers of the flame, like saxophonist Kamasi Washington. The giant stage is large enough to hold a big band and a full-sized piano, and dancers in their Sunday best flash their smiles in front of the bandstand. Some audience members bring their own lawn chairs to fill the sidewalks while others are in constant movement, greeting old friends and new acquaintances.

The emphasis on history is very strong at the festival. For the first time in years, the newly renovated Dunbar Hotel was opened up to visitors, and young musicians, like trombonist Ryan Porter, rocked the skylights with their vibrant funk. On the side streets, small tents were set up for groups selling books, paintings, clothing, and the occasional progressive pamphlet.

These days, the Lincoln Theater functions as a Spanish-language church. Memories of Lena Horne have long faded, but the structure is still kept in good shape. Although it is only a couple of miles away from the much-heralded movie palaces of Broadway downtown, the 2,100-seat venue is largely forgotten and awaiting another revival.

This unsigned mural at Forty-first Street (east of Central Avenue) hints at the history around Central Avenue. The vibrant caricature of musicians locked in ecstasy, which is nearly 30 feet long, reminds residents that the sidewalks were once loaded with instrument cases and that live music used to burst from every storefront.

The Central Avenue Jazz Park is a small strip of land directly across the street from the Dunbar Hotel. A playground and small stage keep children happy. This was the original site of the Central Avenue Jazz Festival until, thankfully, it outgrew the side street and traded up to the avenue. Note the small sign tacked to the post advertising various Mexican foods. As of 2014, the population of the neighborhood had become 75 percent Latino, ushering in a new era of underserved minorities in southern Los Angeles.

Local artist Robin Strayhorn helped students to create the tile mural that hangs above the stage at the Central Avenue Jazz Park. It is badly neglected and covered in vines, stickers, and graffiti. Nonetheless, it must make the kids think about what used to go on in this neighborhood before there was a playground to play on and inexpensive quesadillas for sale. These tiles honor Melba Liston, Duke Ellington (above), and Ray Charles (below), who lived at the Dunbar Hotel when he first arrived in Los Angeles.

Charles Mingus, Lionel Hampton, and the famed Pig N Pit barbecue (which was located at 4200 South Central Avenue) are honored on the tile above. The Club Memo and Duke Ellington's right-hand man Billy Strayhorn are honored on the tile below.

Pianist Paul Bryant, known affectionately as the "Central Avenue Kid," was a youthful presence on Central Avenue. He starred in several films as a child before releasing records with the Pacific Jazz label and Billie Holiday, who shares the above tile with him. The genre and the feel are recognized on the tile below, which also marks the famed Downbeat bar that was located across the street.

Charlie Parker, Dexter Gordon, and Dizzy Gillespie are recognized for their great achievements in jazz (above) while Clora Bryant and Big Joe Turner roll around the notes blasting out of a saxophone, exemplifying the diversity of sound and experience that echoed on Central Avenue for over 40 years.

# Discover Thousands of Local History Books
# Featuring Millions of Vintage Images

Arcadia Publishing, the leading local history publisher in the United States, is committed to making history accessible and meaningful through publishing books that celebrate and preserve the heritage of America's people and places.

Find more books like this at
**www.arcadiapublishing.com**

Search for your hometown history, your old stomping grounds, and even your favorite sports team.

Consistent with our mission to preserve history on a local level, this book was printed in South Carolina on American-made paper and manufactured entirely in the United States. Products carrying the accredited Forest Stewardship Council (FSC) label are printed on 100 percent FSC-certified paper.

**MADE IN THE USA**